HOW TO DRAW ANIMALS
FOR THE ARTISTICALLY ANXIOUS

FAYE MOORHOUSE

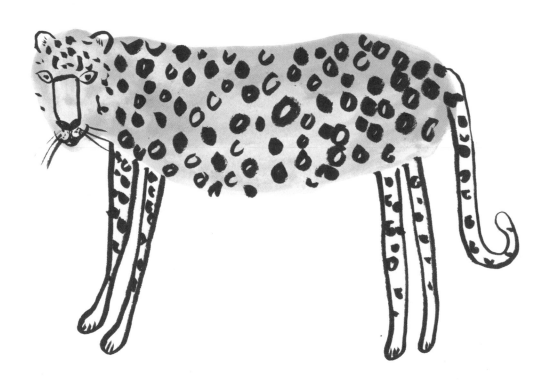

HARPER

ILLUSTRATED BY FAYE MOORHOUSE
EDITED BY LUCIENNE O'MARA, SOPHIE SCHREY AND PHILIPPA WINGATE
DESIGNED BY ZOE BRADLEY

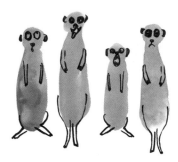

First published in Great Britain in 2017 by LOM ART, an imprint of Michael O'Mara Books Limited,
9 Lion Yard, Tremadoc Road, London SW4 7NQ www.mombooks.com

HOW TO DRAW ANIMALS FOR THE ARTISTICALLY ANXIOUS

Published in 2018 by
Harper Design
An Imprint of HarperCollins*Publishers*
195 Broadway
New York, NY 10007
Tel: (212) 207-7000
Fax: (855) 746-6023
harperdesign@harpercollins.com
www.hc.com

Distributed throughout North America by
HarperCollins Publishers
195 Broadway
New York, NY 10007

ISBN 978-0-06-269150-7
Library of Congress Control Number 2017935991

Printed in Malaysia

Second Printing, 2023

INTRODUCTION

Does the sight of paper, pens, and paints make you panic?
Can the fear of creating a less-than-polished piece of art make you anxious?
Fear no more. A rescue remedy awaits.

This book is a safe space for you to let loose your inner artist, without
the pressures of precision and perfection. Eradicate your eraser—shaky
lines, scribbles, and splotches are all welcome. They are applauded.
Hooray for weird and wonky art!

Transform a multitude of painty splotches into animals, from meerkats
to mice. Each spread features a different animal, with a watercolor
shape and suggested features for you to copy or take inspiration from.
Allow Faye Moorhouse's illustrations to guide you, help you, and
celebrate quirkiness in all its glory.

You are as unique as the animals in this book.
What are you waiting for?
LET'S DO THIS!

FLAMINGO

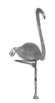
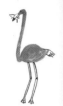
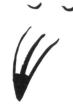

Dreaming
about fish

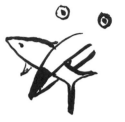

YAY! Caught
a fish

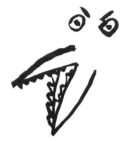

He stole
my fish!

Gutted

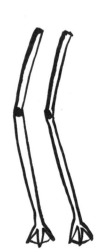

Normal legs

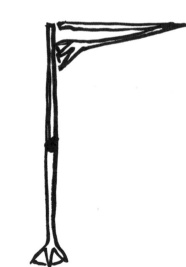

Sleeping
legs

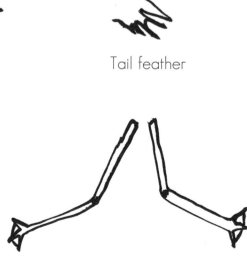

Tail feather

Had-one-too-many-
cocktails legs

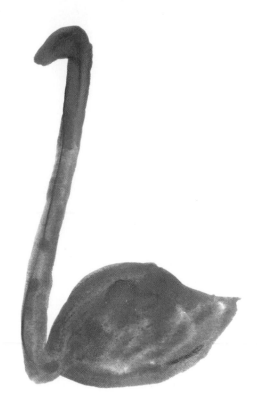

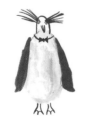
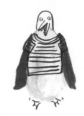

PENGUIN

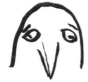

Sad face

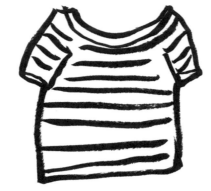

Striped sweater

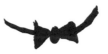

Bow tie

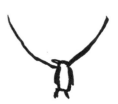

Necklace

Smelled-a-bad-fish face

Angry face

Egg

Happy feet

Too much mascara

Feet

Shy feet

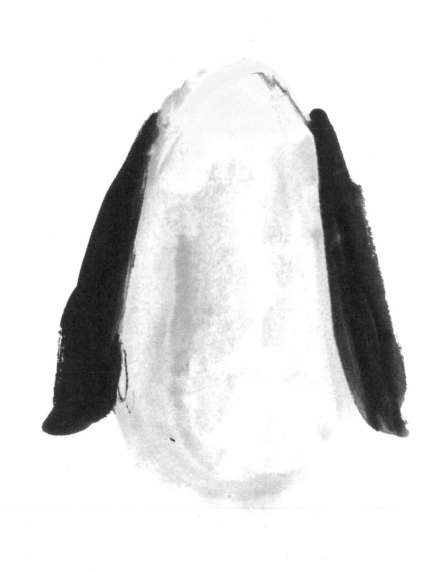

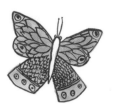 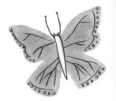

BUTTERFLY

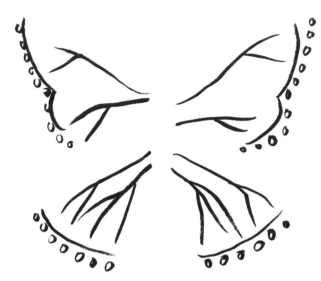

Everyday wings

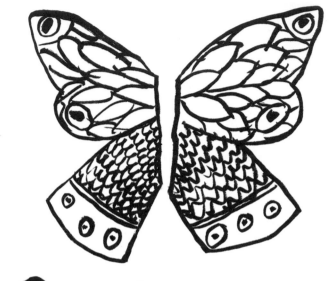

Party wings

Eyes

Antennae

Body

A light lunch

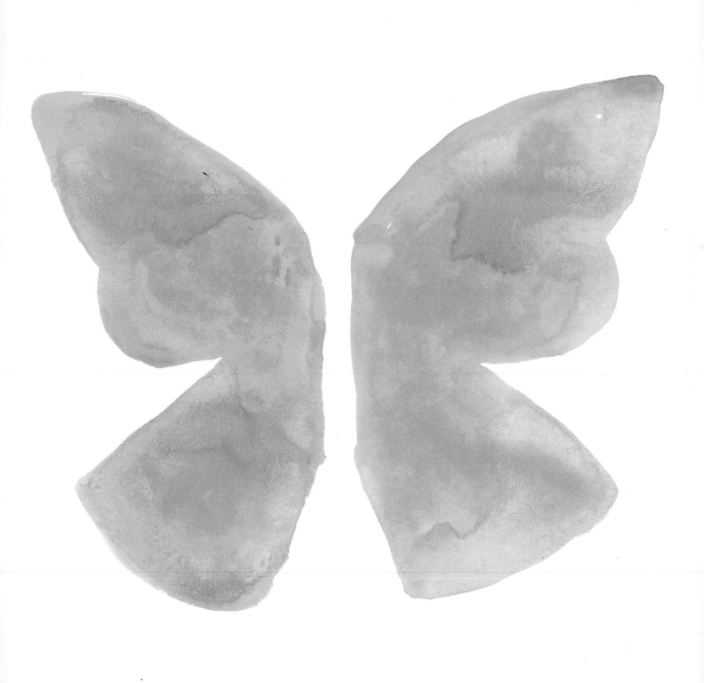

BEAR

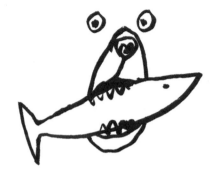

Salmon for supper

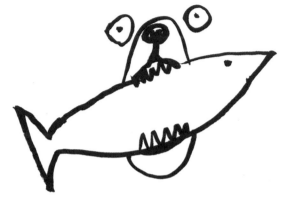

HUGE salmon
for supper

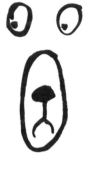

Enforced diet

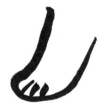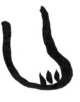

Legs

Ears

Arms

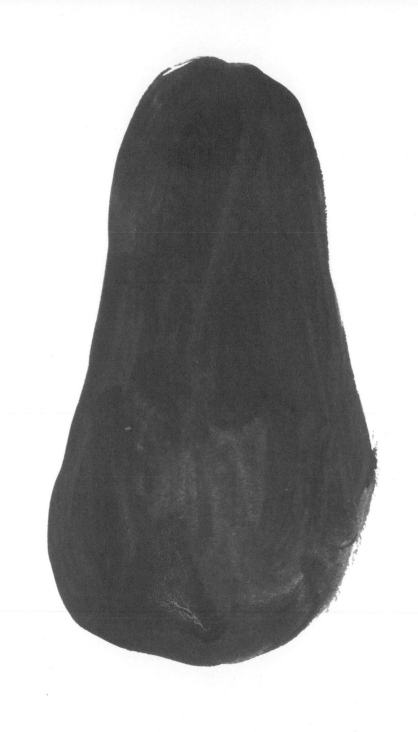

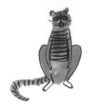
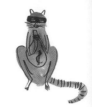

RACCOON

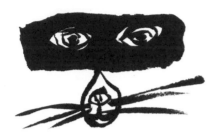

Masked
avenger

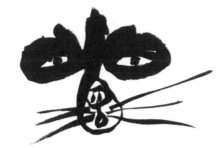

Burglar

Ears

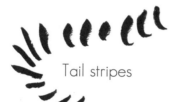

Tail stripes

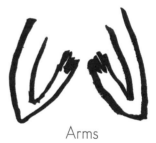

Arms

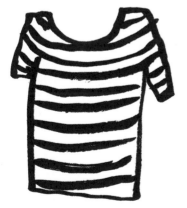

Striped burglar shirt

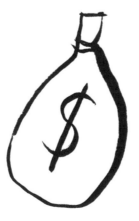

Swag bag

Legs

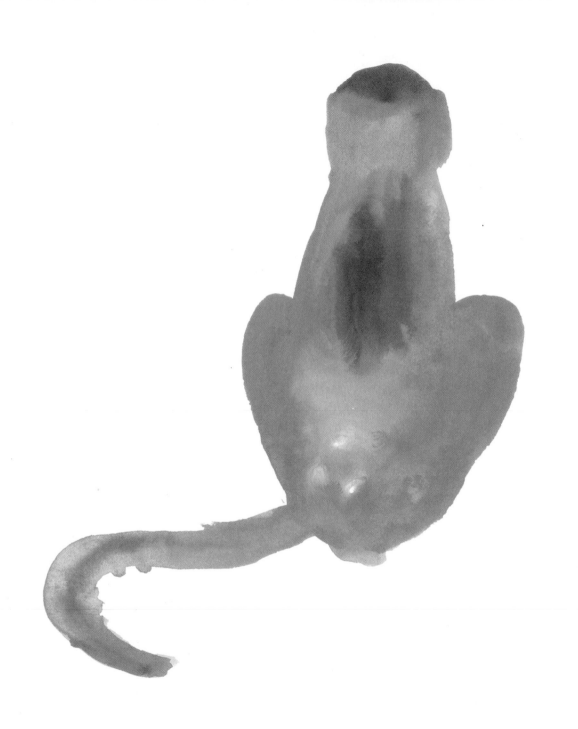

DOG

Need to be pet

I ♡ being pet

OK. Too much petting

Eyes

Happy tail

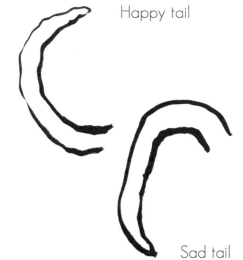

Sad tail

Collars

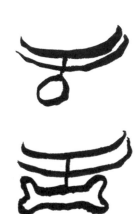

Front legs

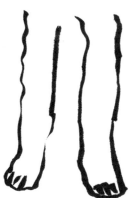

Back legs

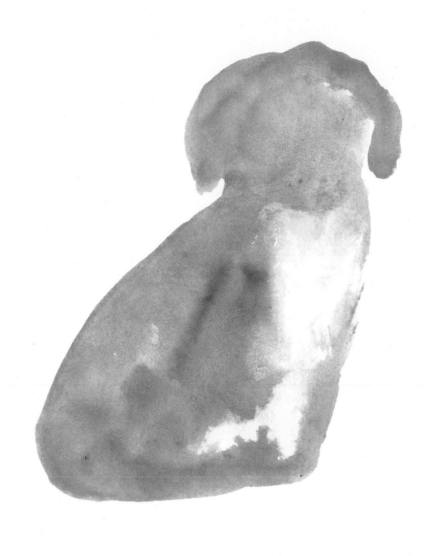

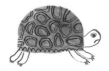
TORTOISE
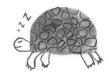

Simple shell

Fancy shell

Dancing feet

Tired tortoise

Happy tortoise

Attack tortoise

PANDA

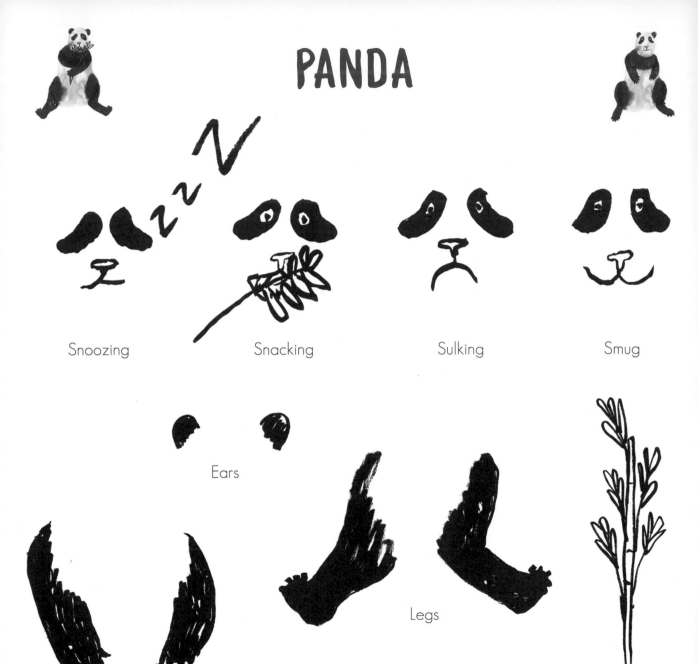

Snoozing

Snacking

Sulking

Smug

Ears

Arms

Legs

Bamboo

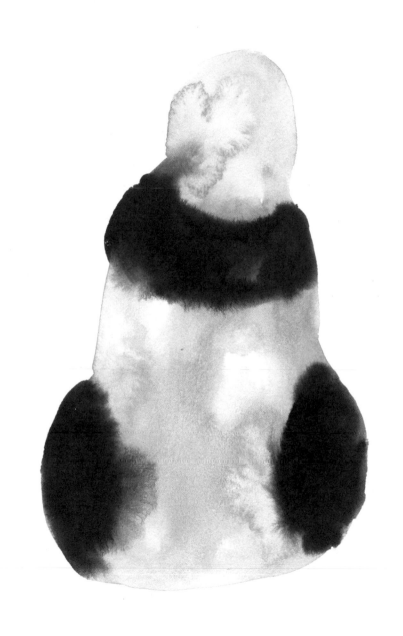

CAMEL

A magic carpet

Amorous smile

Kiss me, quick!

Lots of luggage

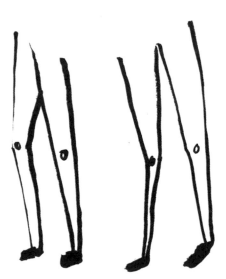

Legs

Tail

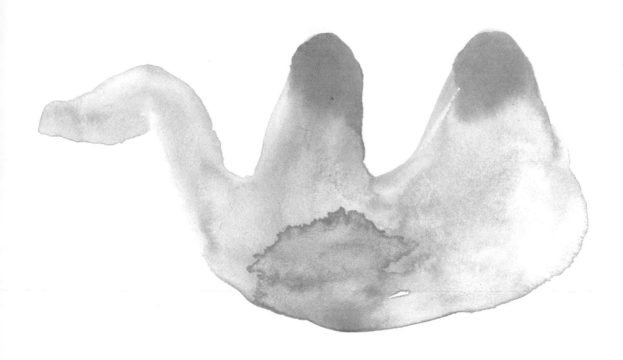

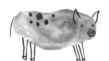 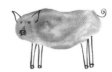

PiG

Possessed

Surprised

Down in the dumps

Spots

Happy tail

Hair

Sad tail

Legs

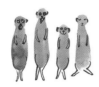 # MEERKATS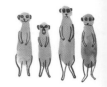

Daydreamer

Mischievous

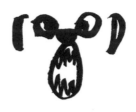

Anger issues

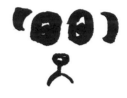

Bored now

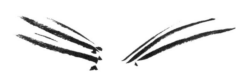

Whiskers

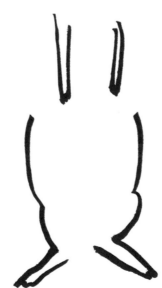

Fur

Just chillin'

DANGER!

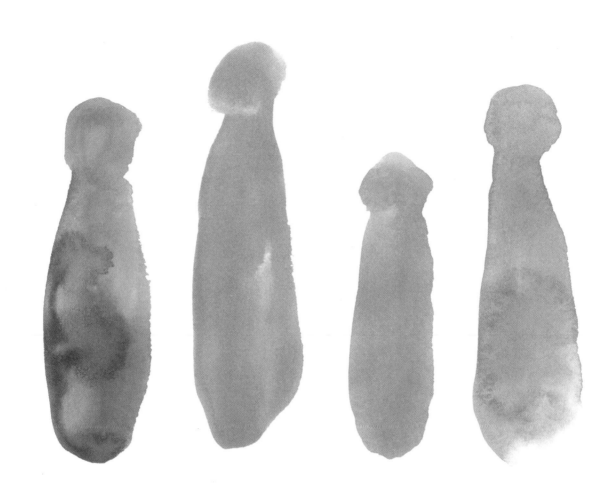

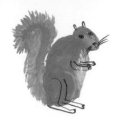

SQUiRREL

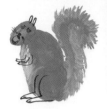

 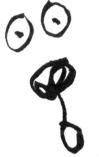 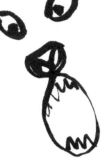 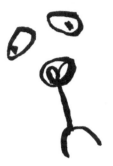

Hungry
face

Confused
face

Shocked
face

Fierce face

Sad face

Whiskers

Legs

Arms

Ears

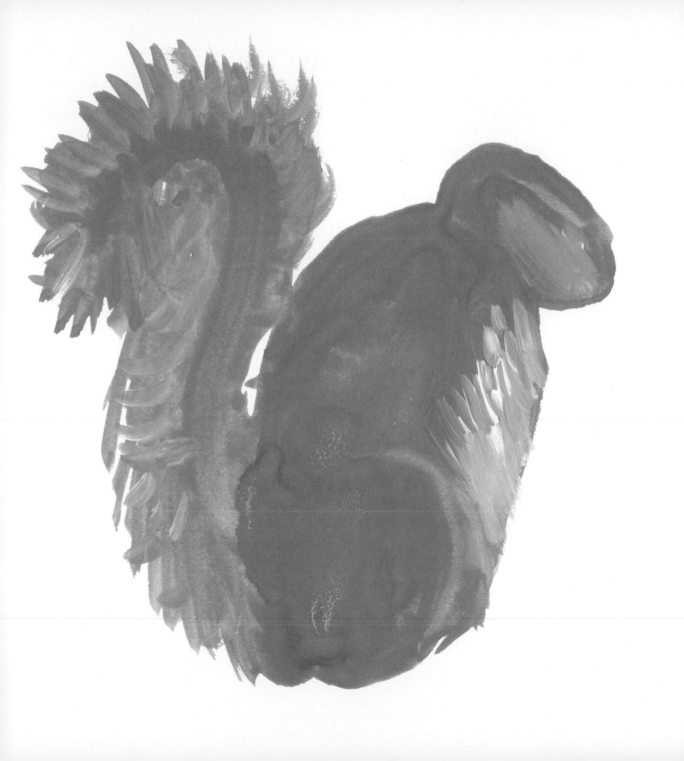

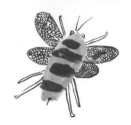

BEE

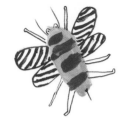

Simple wings

Antennae

Eyes

Striped wings

Stinger
(don't touch!)

Six legs

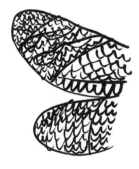

Fancy wings

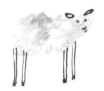

SHEEP

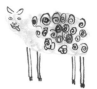

Perm

Ate too much grass

Don't mess

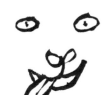

Mischievous

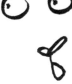

Sheepdog alert!

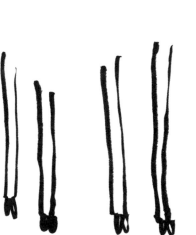

Legs

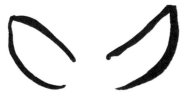

Big ears

Small ears

PEACOCK

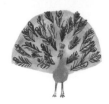
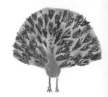

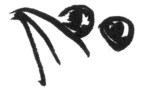
Snooty

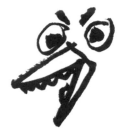
Vexed

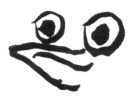
Troublemaker

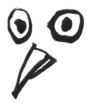
Buzzing

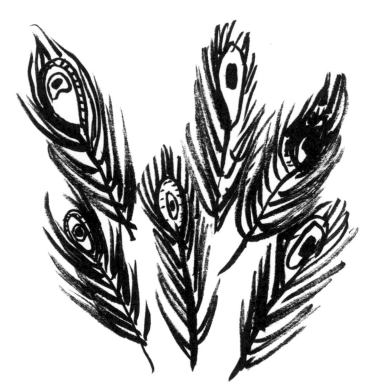
Fabulous feathers

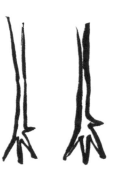
Legs

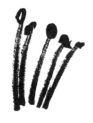
Crest

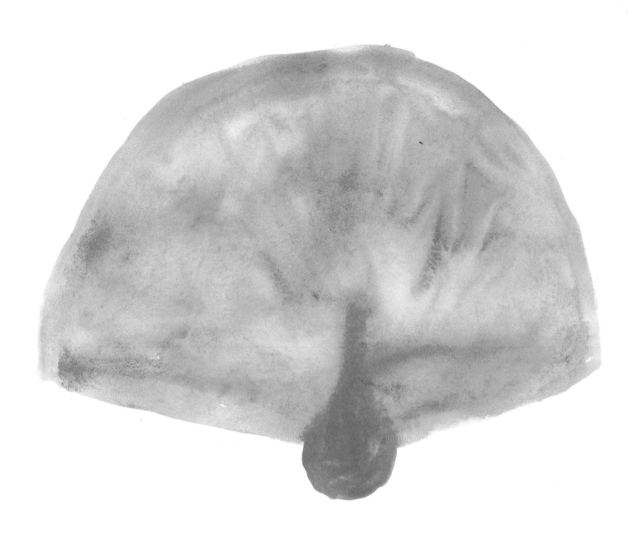

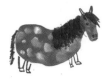

SHETLAND PONY

Groomed mane

Sleep deprived Friendly

Messy mane

Short legs Tail Ears

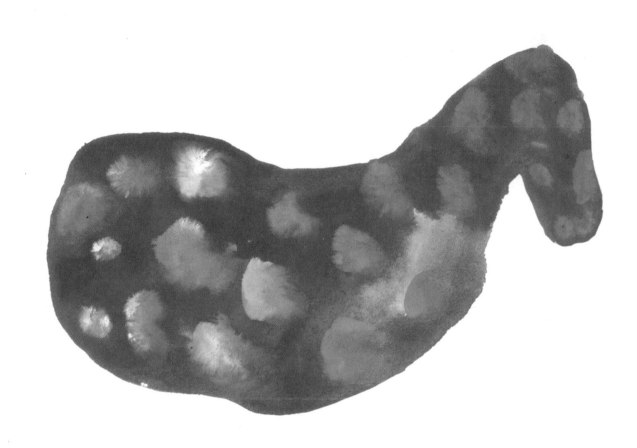

CAT

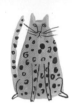
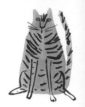

Tortoiseshell

Eyes

Front legs

Tabby

Back legs

Bengal

Which tail shall
I wear today?

Devotion

Disdain

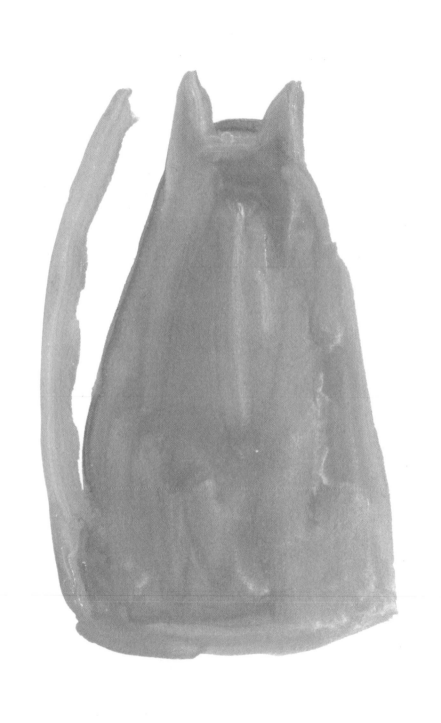

MONKEY

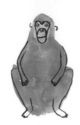
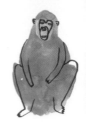

Grumpy
face

Happy
face

Sneezy
face

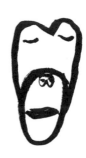
Sleepy
face

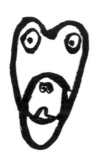
Shy
face

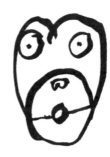
Startled
face

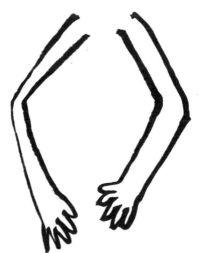
Arms

Legs

Ears

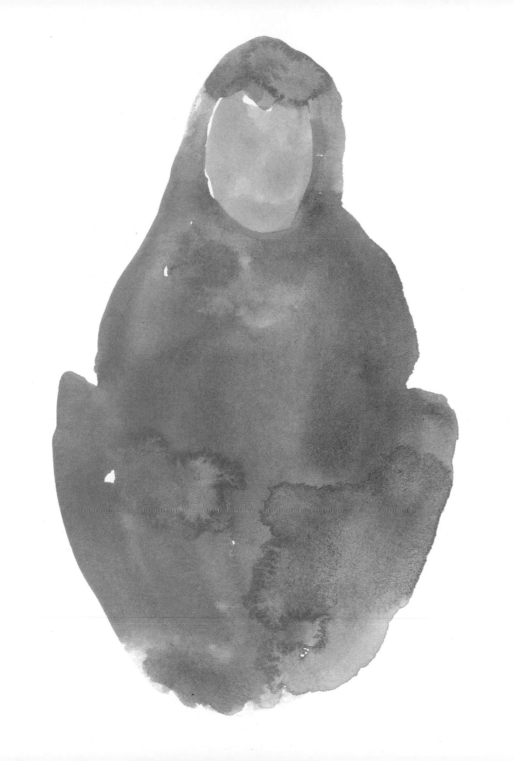

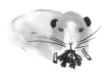

GUiNEA PiG

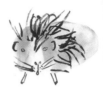

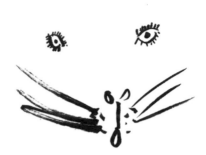

Surprised face

Windswept hair

Lettuce face

Lunch

Blow-dry

Ears

Feet

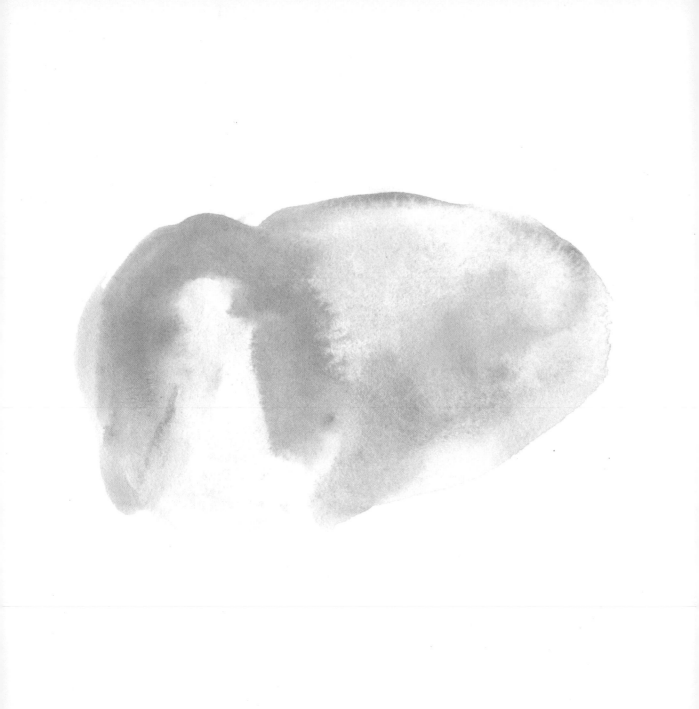

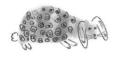

RABBIT

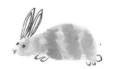

Tall ears

Short ears

Floppy ears

Handlebar ears

Fluffy
tail

Eyes

Nose and
mouth

Curious whiskers

Front paws

Back paws

Curly fur

Bad fur day

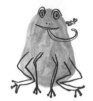

FROG

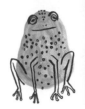

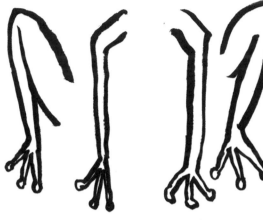

Legs

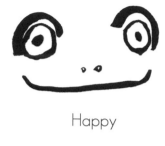

Happy

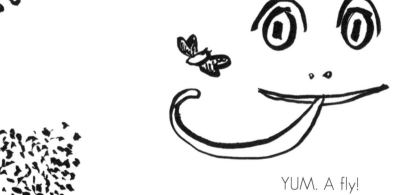

YUM. A fly!

Cute camouflage

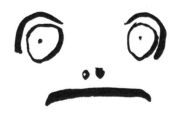

Actually, I think it was a bee

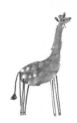
GiRAFFE
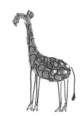

Alert eye

Flirt eye

Mouth

Mmm... leaves

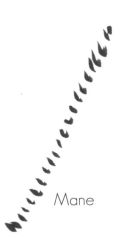

Mane

Horns

Long legs, high heels

Tail

Ears

Patches

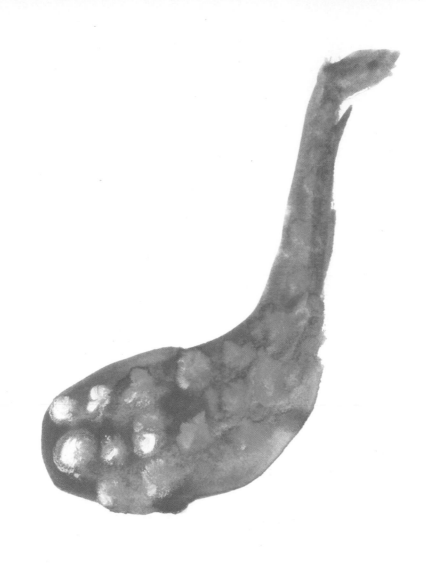

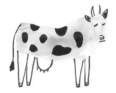

COW

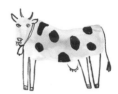

Why the long face?

Horns

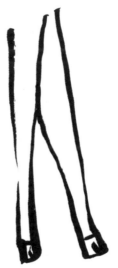

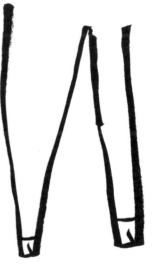

Back legs

Front legs

Ears

Tail

I'm over here

Splotches

Udder

SHARK

 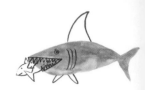

Happy shark

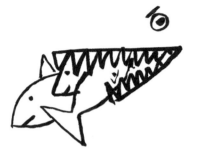

Fish-eating shark

Hammerhead shark

Gills

Baby fin

Adult fin

Great white fin

Belly fins

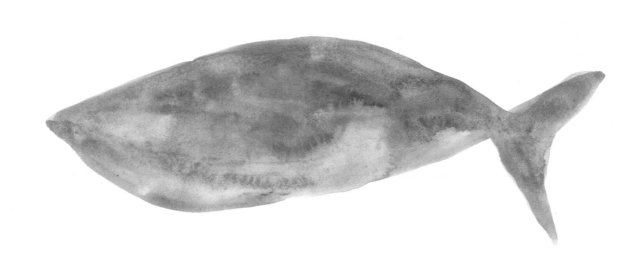

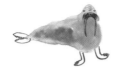 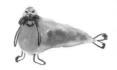

WALRUS

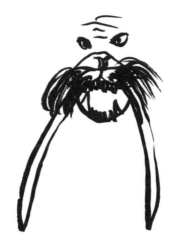

Not impressed

Needs a shave

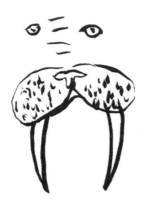

Shaving rash

Front flippers

Tail

Extreme-aging wrinkles

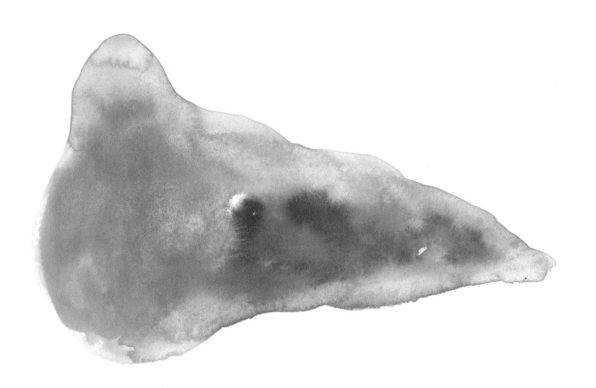

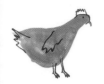

CHICKEN

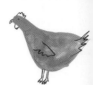

Beady eye

Feet

Small beak

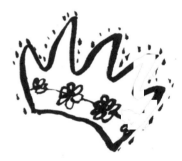

Simple crest

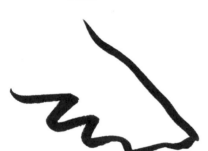

Wing

Medium beak

Jazzy crest

Tail feathers

Large beak

Bad hair day

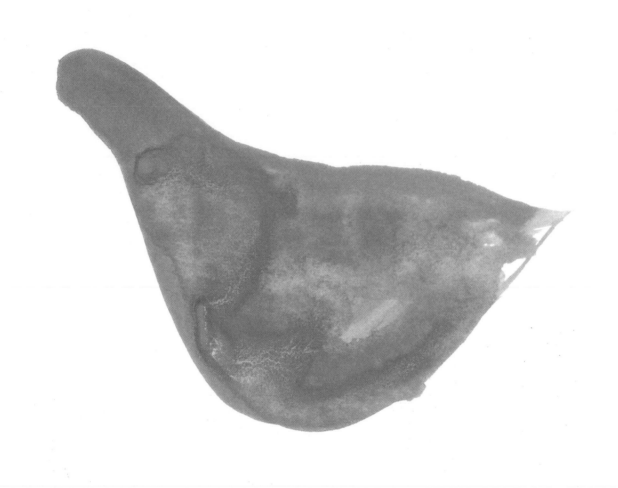

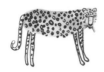

LEOPARD

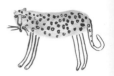

Actually, you *can* change
a leopard's spots

Tail

Ears

Whiskers

Legs

Glum face

Game face

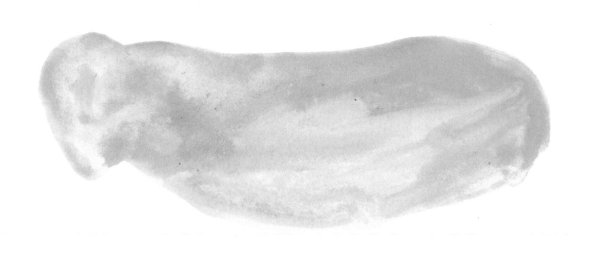

KOALA

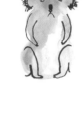

Fluffy ears

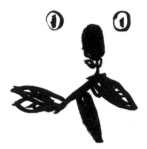

YUM!

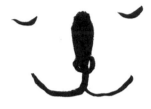

Super chilled

Spiky ears

Eucalyptus branch

Arms

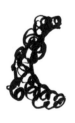

Ear muffs

Legs

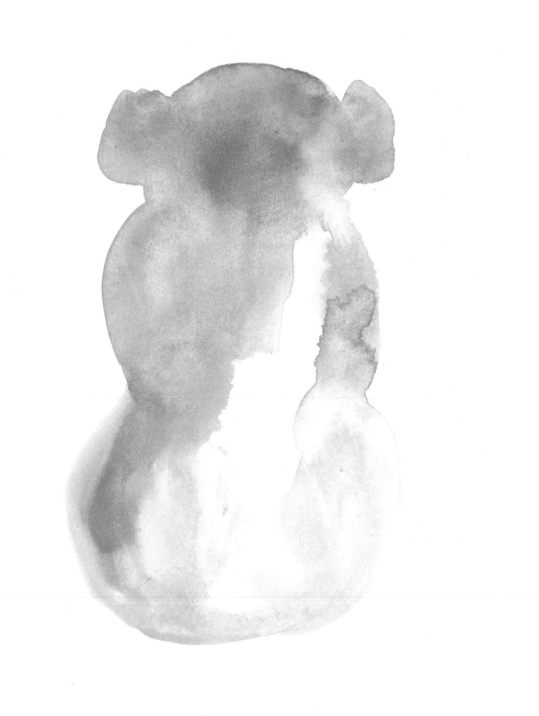

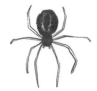

SPiDER

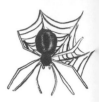

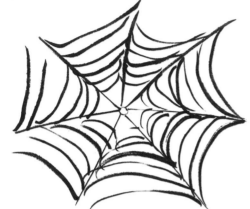

Neat
spider's web

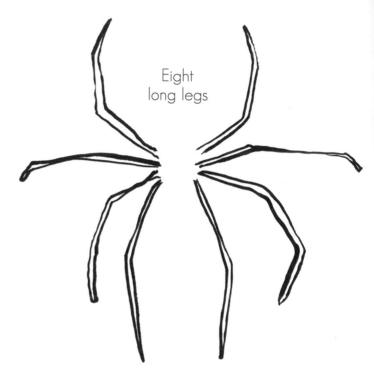

Eight
long legs

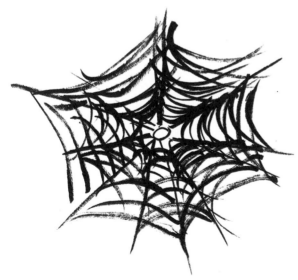

Messy
spider's web

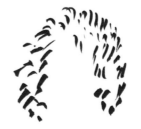

Hair

Eyes

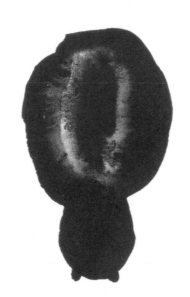

POODLE

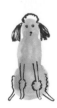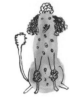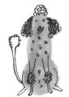

Fancy bouffant

Simple, understated
curls

Eyes

Pom-pom tail

Feeling
coy

Feeling
good

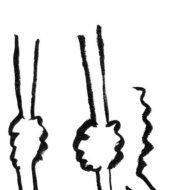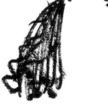

Fluffy ears

Legs

Curls

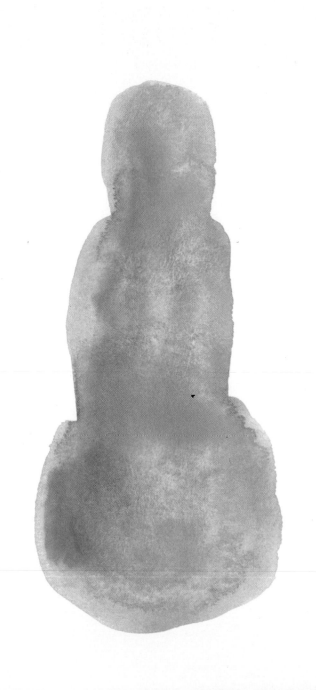

OSTRICH

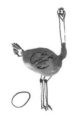

Are you looking at my egg?

Do NOT take my egg

STEP AWAY FROM THE EGG!

Egg

Legs

Tail feathers

Hair

Body feathers

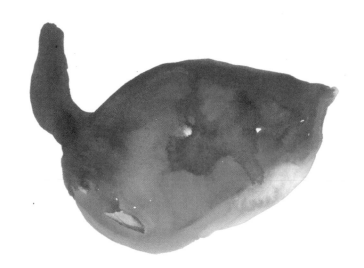

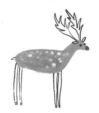 # DEER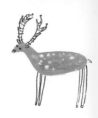

Small antlers

Boss antlers

Christmas antlers

Eyes

Ears

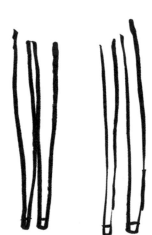

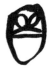

Nose and mouth

Tail

Legs

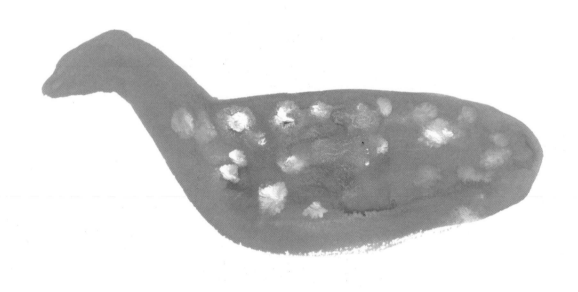

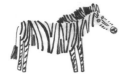

ZEBRA

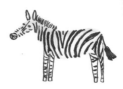

Dainty ears

Eyes

Stripes

Nose and
mouth

Hairy ears

Messy mane

Legs

Tail

Punk piercing

Styled mane

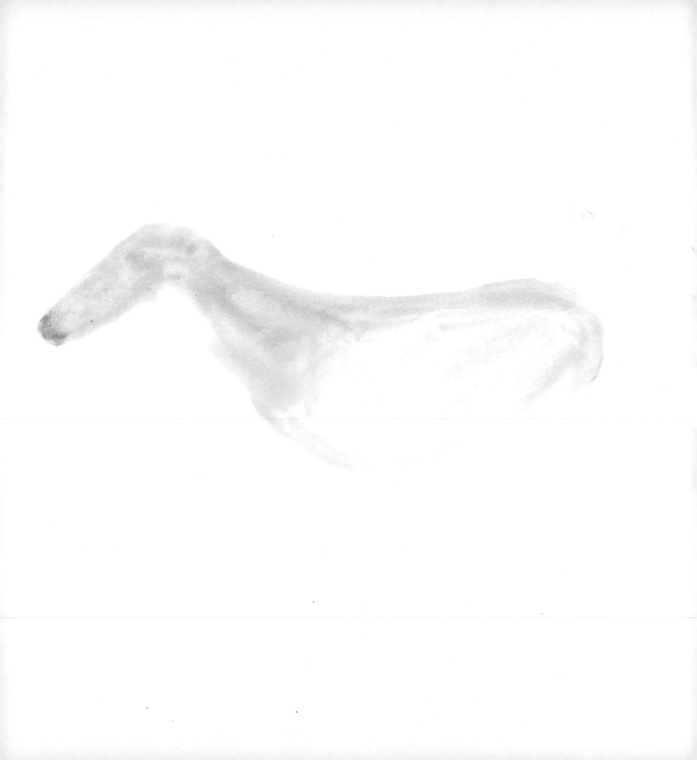

SNAKE

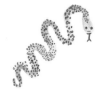

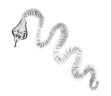

Look into my eyes

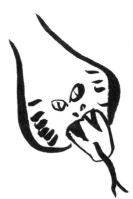

Back off

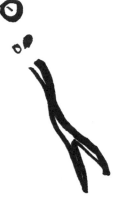

Ouch, I bit my tongue

Shake your rattle

Crosshatch pattern

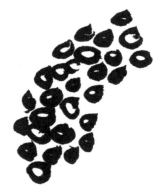

Polka dot

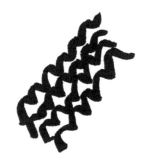

Scaly skin

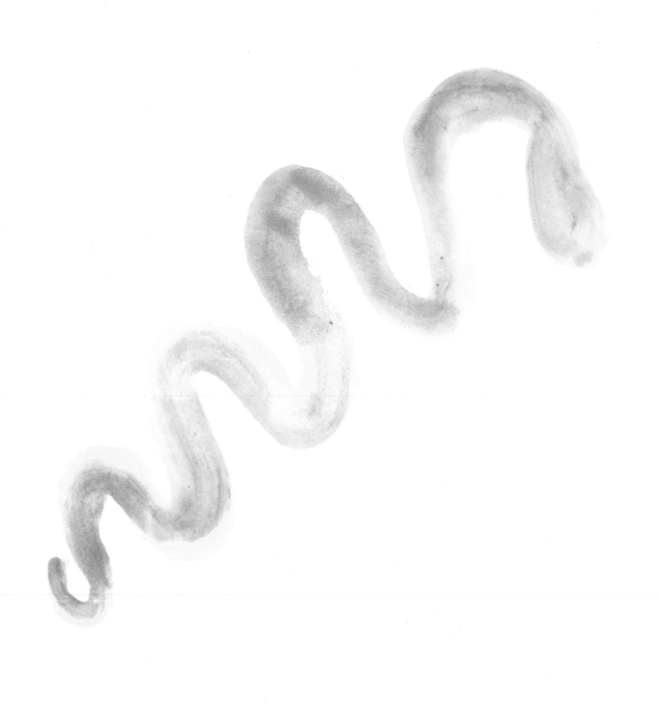

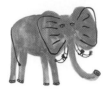
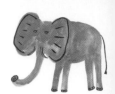

ELEPHANT

Enormous ears

Curly tusks

Tiny tusks

Eyes

Nostrils

Toes

Tail

Bollywood tusks

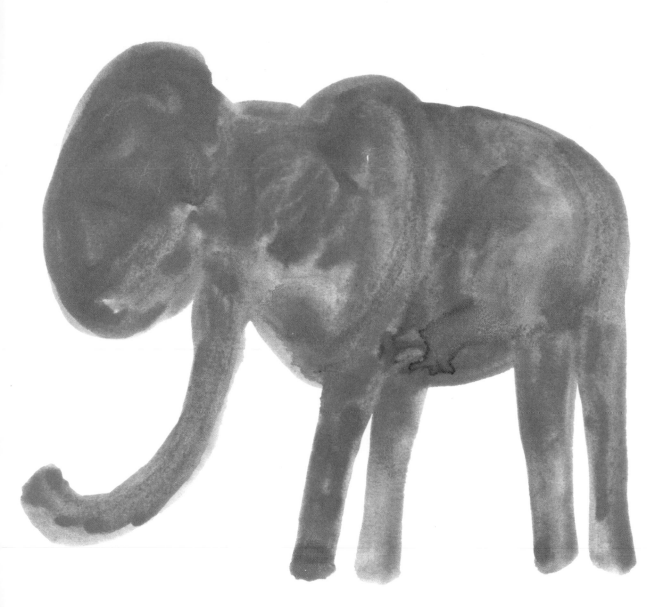

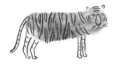 # TiGER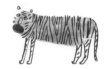

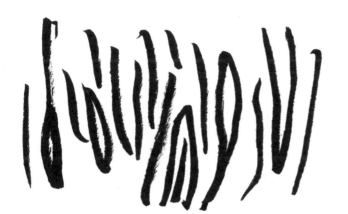

Stripes

GRRRR!

Indifferent

Surprised

Sad

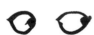

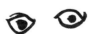

Pick 'n' mix eyes

Whiskers

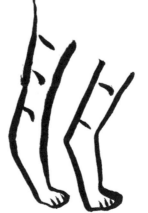

Back legs

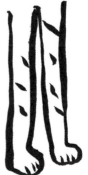

Front legs

Ears

Tail

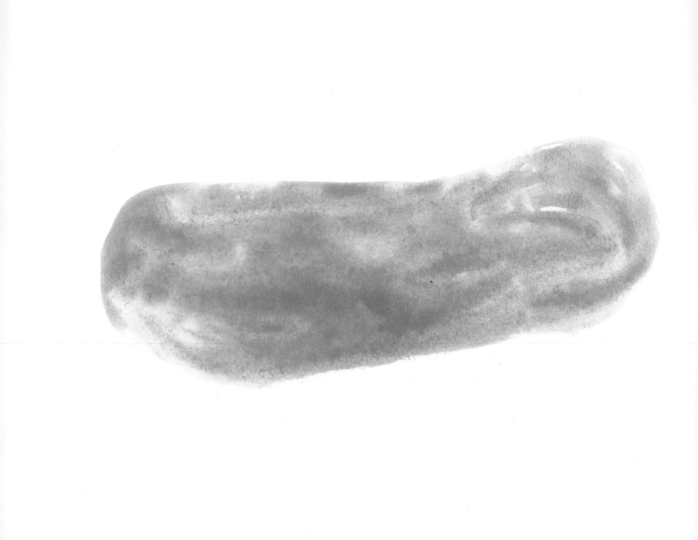

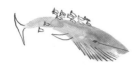

WHALE

Grooves

Front fin

Whale tail

We're with the whale

Angry face

Sad face

Happy face

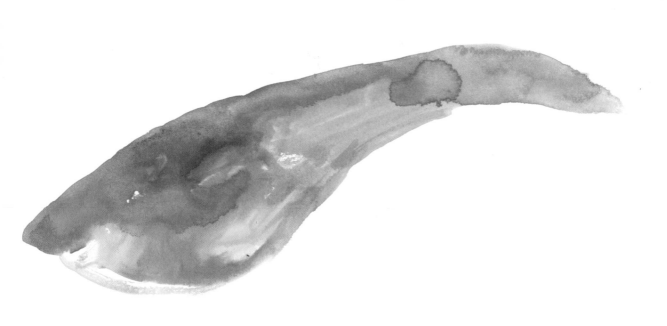

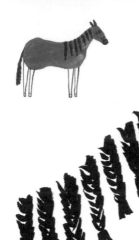

HORSE

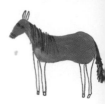

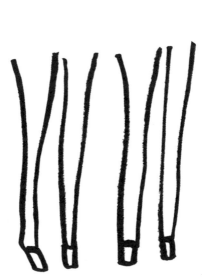

Braided mane

Short mane

Mane in bows

Flowing mane

Angry face

Pretty face

Tail

Clip-clop

Ears

Stuffing my face

Burp!

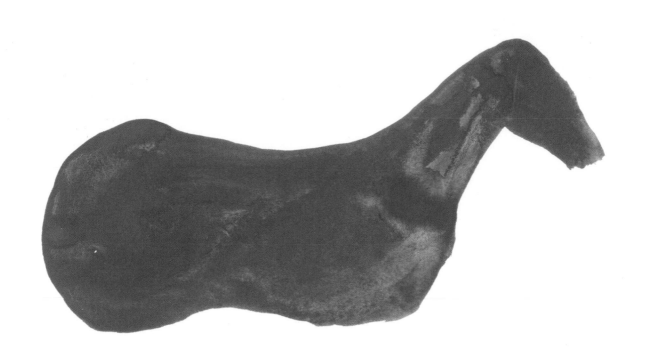

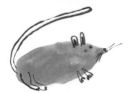 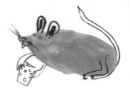

MOUSE

Ears

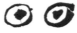

Eyes

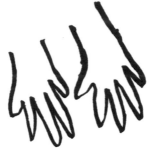

Greedy paws

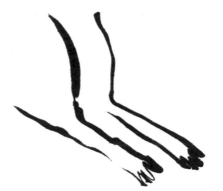

Back legs

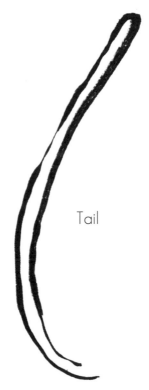

Tail

Tiny paws

Nose and mouth

Cheese!

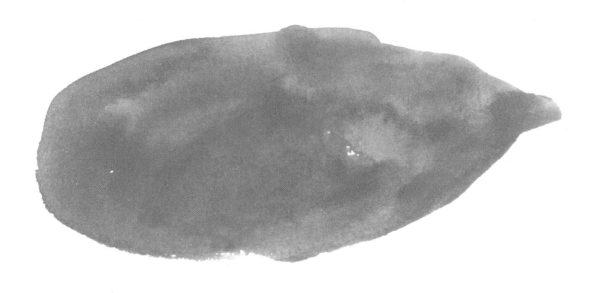

LiON

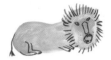
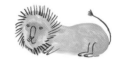

 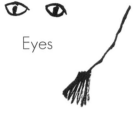

Eyes

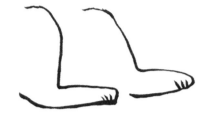

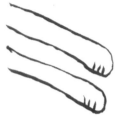

Tail

Back legs

Front legs

Pick 'n' mix noses and mouths

Groomed mane

Bad hair day

ELECTROCUTED!

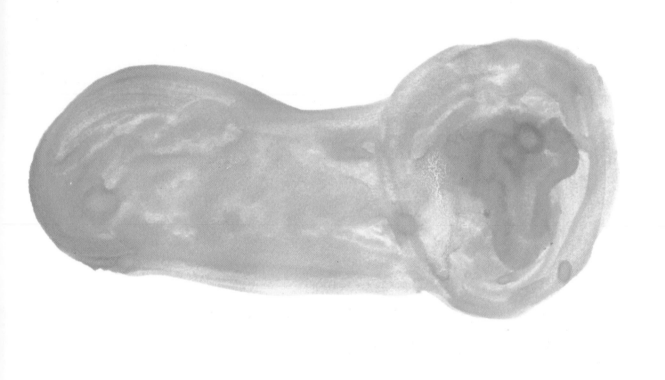

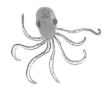

OCTOPUS

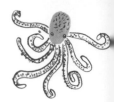

Big eyes

Wrinkles

Shifty eyes

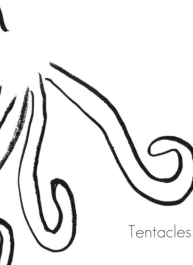

Suckers

Tentacles

HEDGEHOG

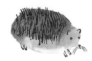 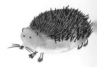

Soft spikes

Spiky spikes

Fauxhawk

Smug

Thoughtful

Leaves

Ears

Legs

RHiNO

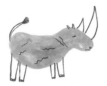

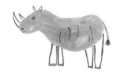

Are you looking
at me?

Big horns

Happy tail

Sad tail

Nose

Tiny horns

Regular legs

Mouth

Wrinkles

These-stockings-are-too-big legs

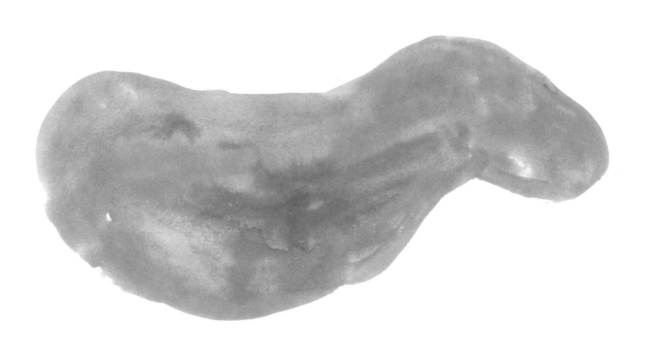

TOUCAN

Svelte body

Wing

Shocked eye

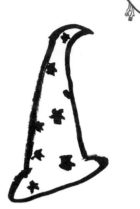

Wizard hat

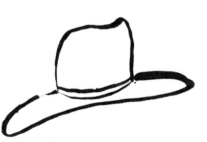

Cowboy hat

Feet

Evil eye

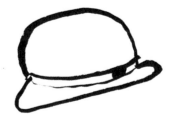

Bowler hat

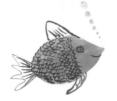

FiSH

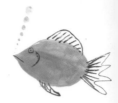

Fins

Plain tail

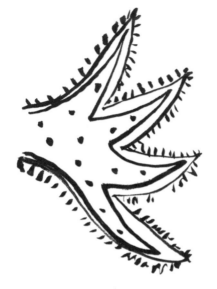

Flashy tail

Mouth

Enormous eye

Scales

Party eye

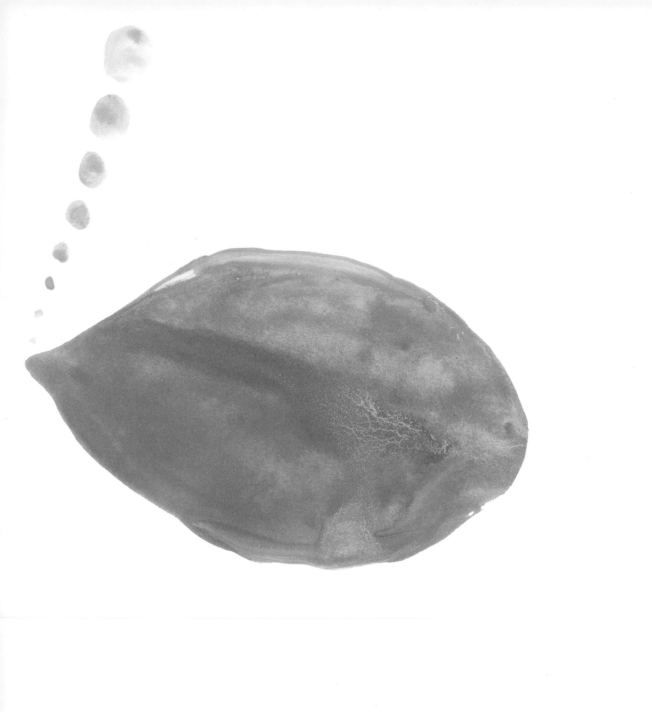

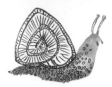

SNAiL

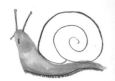

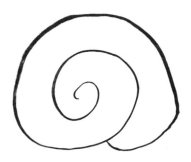

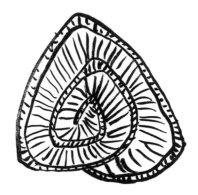

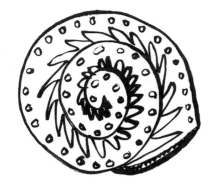

Simple shell

Pretty shell

Disco shell

Angry

Sad

Surprised

Feelers

Full-body tattoo

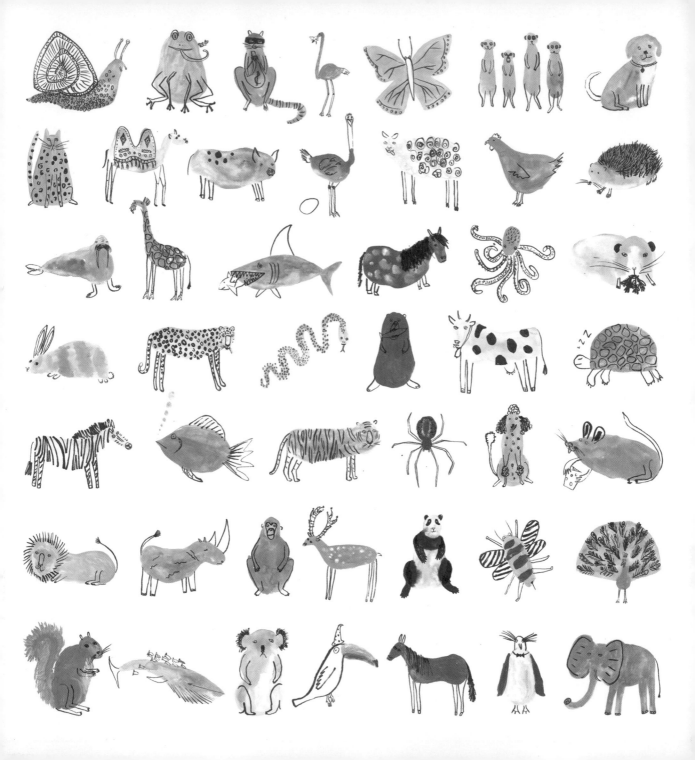